FEMALE

Pilar Vergara

Daylight

D

15 Y E A R
ANNIVERSARY

Cofounders: Taj Forer and Michael Itkoff
Creative director: Ursula Damm
Copy editor: Elissa Rabellino

ISBN 978-1-942084-49-5

Printed by Kopa.

Daylight Books
Email: info@daylightbooks.org
Web: www.daylightbooks.org

For my daughter, Alex, and my son, Martin.

UNIQUELY DIFFERENT

By Giselle Michaels

It is a commonly accepted axiom that no two people are alike. Even identical twins are singular individuals, each with their own distinctive differences. We say things like "To each his own way" to express that every person also has their own affinities and inclinations. But in a world where people are just as unique as snowflakes, we cling to traditions that force people to live in boxes of expectations.

In my generation, gender expectations were the roadblock that prevented most women from competing in sports or finding employment beyond entry-level positions. Gender expectations nearly ended the career of a brilliant songwriter and pianist named Elton John because men weren't "supposed to" have intimate relations with other men. And so when I first became aware of my effeminate nature and my dream of being a girl somewhere between the ages of five and seven, it was instantly clear even for a small child that these things could never be. Like most of the transgender people

born in the 1960s and 1970s, I didn't know there were others like me who felt out of place in their assigned gender roles. Nobody told me there were medical options available to transgender people.

I was trapped in a gender role that demanded things from me that I couldn't excel at or felt uncomfortable with doing. I avoided the guys playing sports who always picked me last anyway, and I balked at going off the huge jump that my friends built at the bottom of the gully. Instead, I stayed home and pored over my mom's fall issues of *Vogue* and *Harper's Bazaar* when nobody was looking.

By the time I was 14, I had started to figure out that I would never fit in by being myself (in spite of always being told, "You can be anything you want to be"). I watched others who were getting positive attention and created a new persona that emulated those people. I believed that blending in would help me find friends and succeed in

life, and I gravitated toward entertainment, where I found more freedom of expression.

By high school, I had found a measure of success doing those things, though years later some old friends from school remembered that I once told them I would switch bodies with a girl in a heartbeat. And though I pushed away any thoughts of actually changing my body because my studies in science taught me that it was impossible, I found myself borrowing clothes and makeup from my mom and girlfriends just to glimpse the real me looking back in the mirror.

I believe I am incredibly blessed to live in an age where the societal taboos surrounding being transgender are finally being challenged, and physical transition is a viable option for people like me who suffer from gender dysphoria. But it is also a difficult time to be transgender. While our cause benefits from increased visibility, there are still many people who believe we represent a threat to their

traditions and beliefs. Transgender people are relatively uncommon (we're estimated to be about 1 percent of the population of the United States), yet the subject of trans people has become mainstream news in the past few years. Now a society that denied our existence for generations is struggling to understand why we don't fit its binary gender expectations. A great number of people seem to be worried what the existence of trans people says about their traditional gender values.

When you think about it, everything in our society is segregated by gender from before birth. One of the biggest events in most pregnancies is the revelation of the sex of the child. Once that child is born, we begin instilling them with the rules, vocabulary, customs, and expectations that traditionally are associated with that their assigned sex. Adults and peers surrounding them begin to actively sanction any nonbinary inclinations or behavior, and pressure them to conform to cisgender norms.

It is a strange feeling to be part of such a minute segment of humanity while simultaneously being the subject of such spirited discussion by just about everyone. Every day we hear cisgender people asking other cisgender people what they think about trans people. Magazine and news reporters know they can attract attention by getting cisgender celebrities to talk about us whether or not they have any actual knowledge of the topic. So we find that everybody is talking about us, but very few people are listening to us.

Alarmist fears and conspiracy theories are circulated by people who have never taken the time to spend five minutes doing Internet research to learn the basics of gender dysphoria and its genetic and developmental causes. Lay people often have such strong preconceptions of gender that they argue counter to the opinions of gender specialists with decades of experience.

Gender identity isn't like fashion, subject to the latest trends. Instead, gender is an innate attribute of every person that only they can discern. I believe that every person, whether cisgender, transgender, or nonbinary, should be free to express their gender in their own way. We don't have to abolish binary gender standards to accomplish this; we just need to stop policing the people who don't perfectly fit the arbitrary ideals. We should embrace the natural diversity of humankind instead of trying to squelch it.

I dream of a world where I don't have to constantly worry that I'll be rejected or endangered simply for expressing my natural femininity or for identifying as a woman. We are living at a pivotal point in transgender culture. I believe that 50 years down the road, everyone will wonder what caused all the controversy.

As for myself, I'm just a girl who is looking forward to spending my later days in a purple dress with a red hat and finally having enough time to tend my garden.

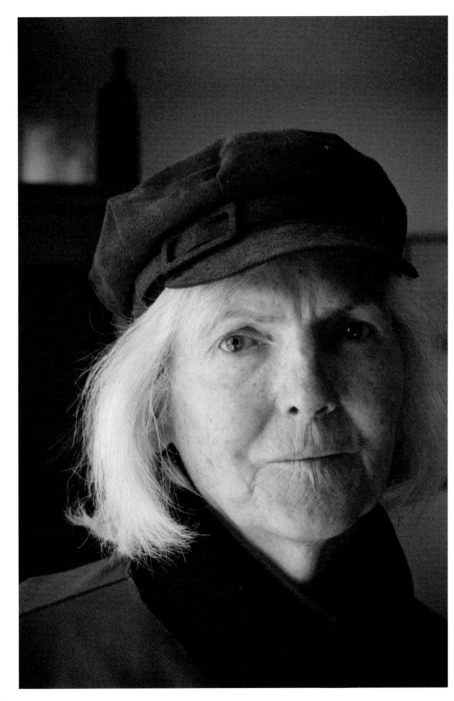

LAURA, computer engineer

Interview: p.20

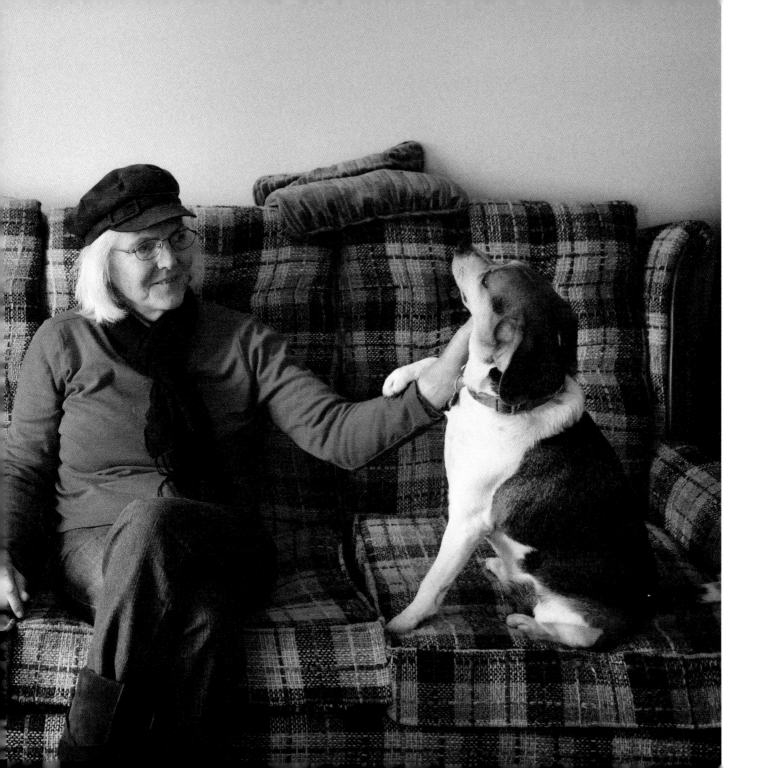

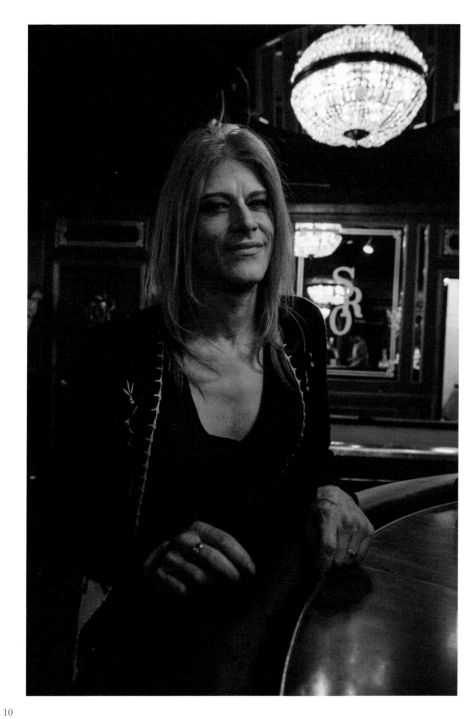

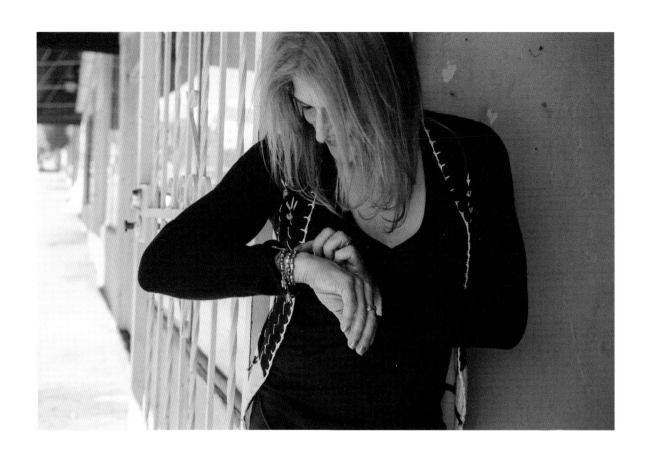

GISELLE, musician and composer

KATHY, government administrator

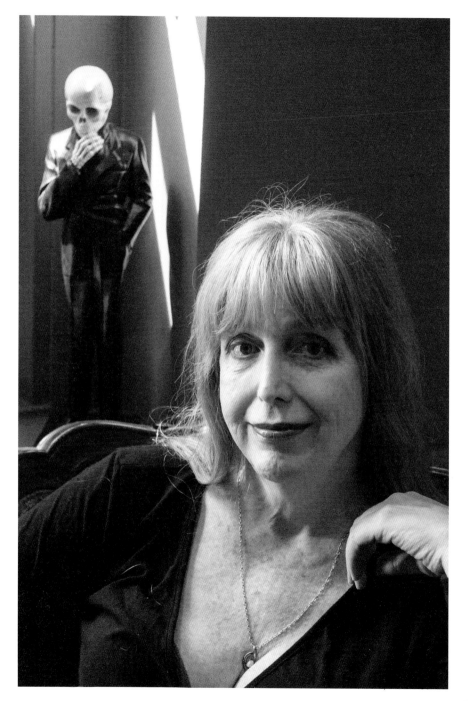

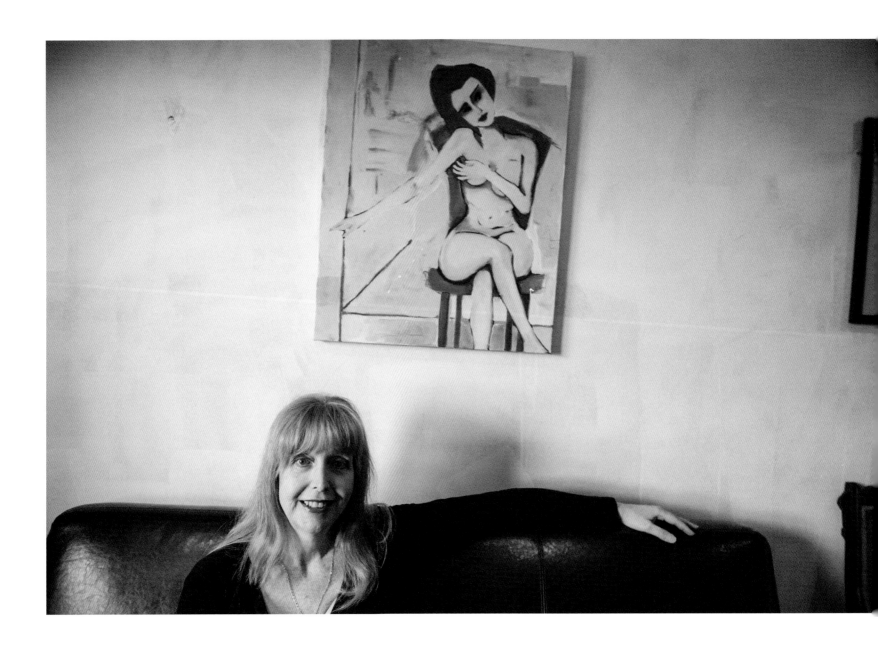

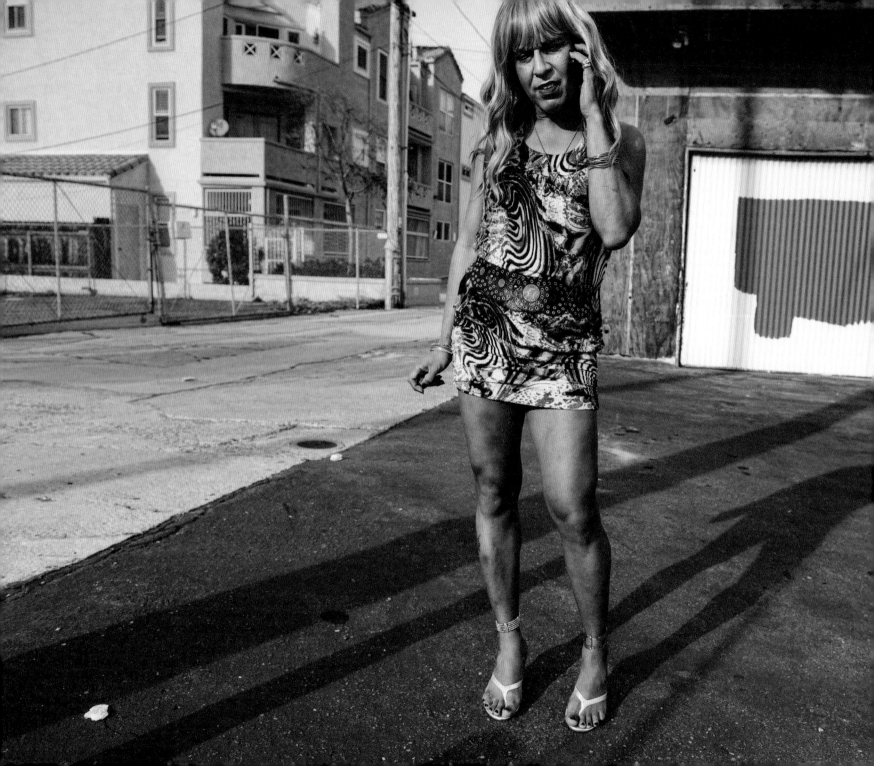

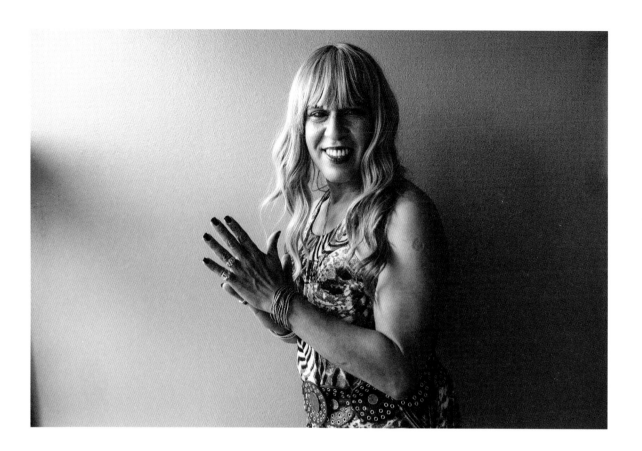

KATHY, government administrator

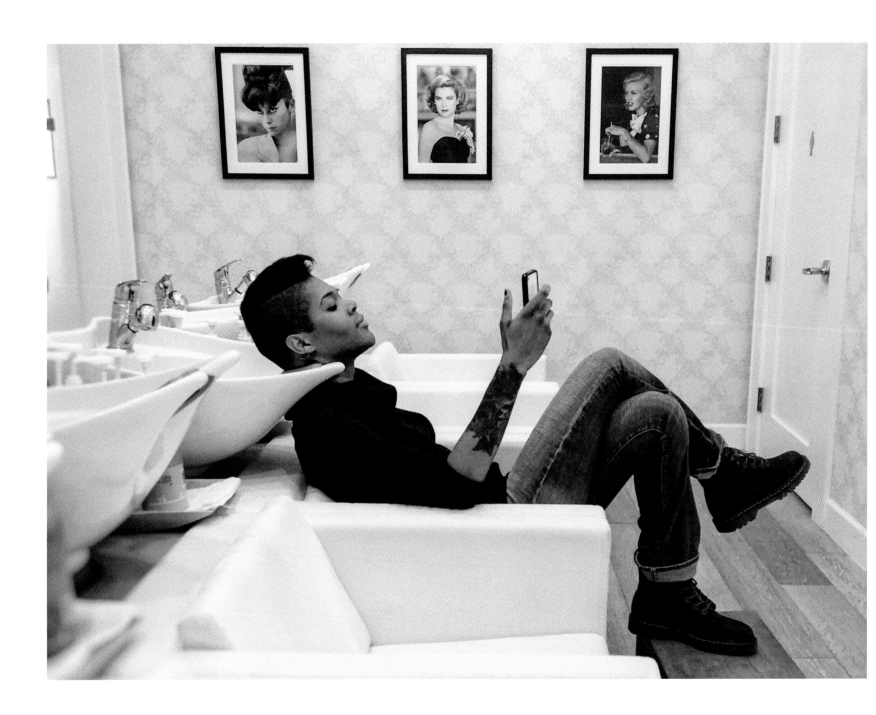

BRANDI, hairdresser

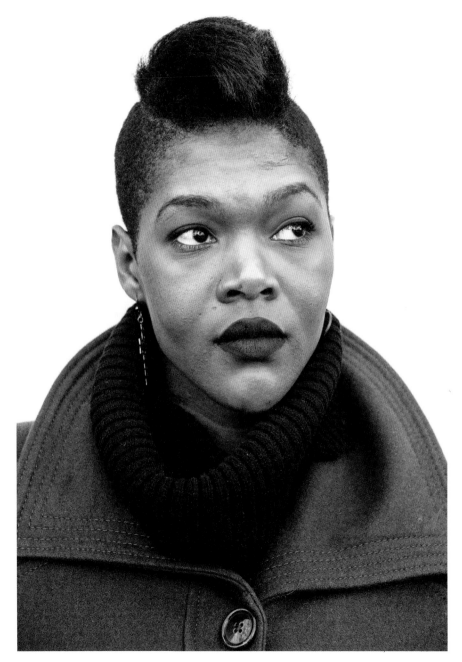

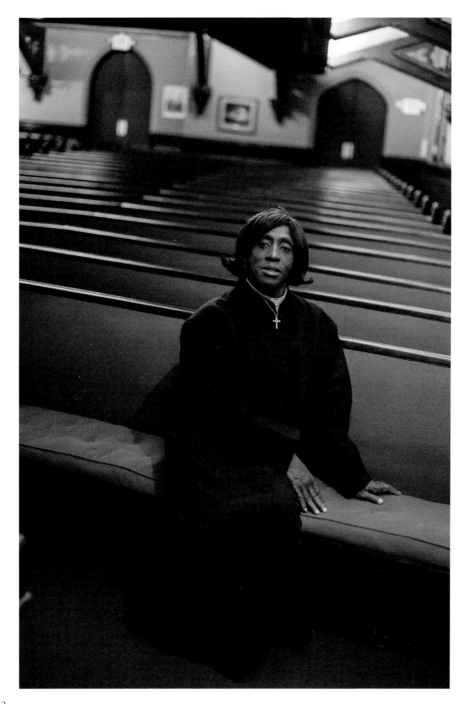

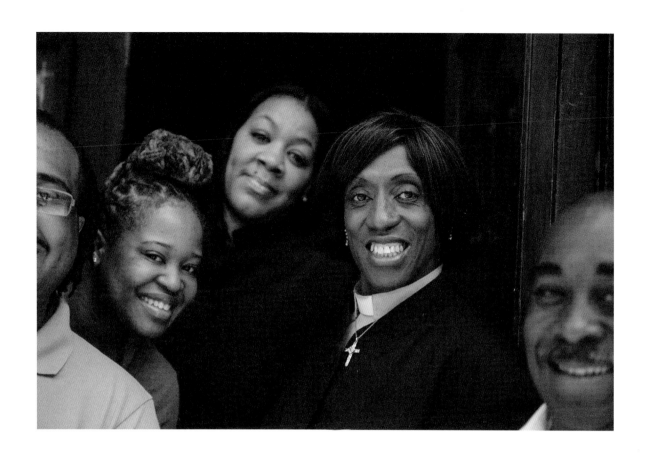

CHARLENE (late), minister

MARA, software engineer
Interview: p.22

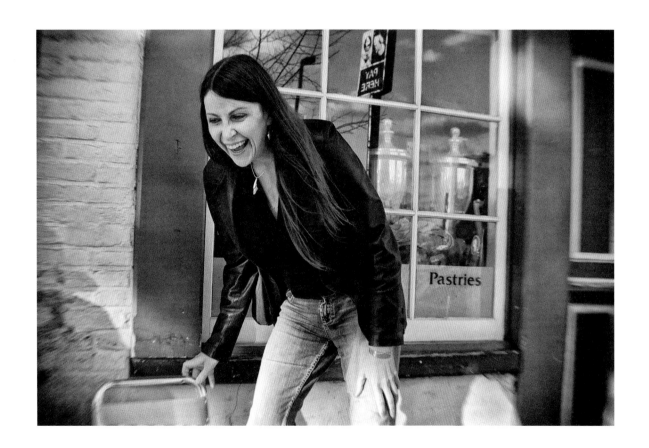

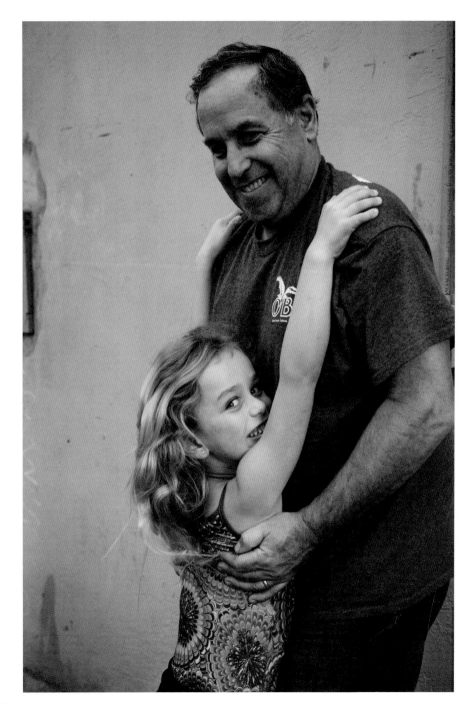

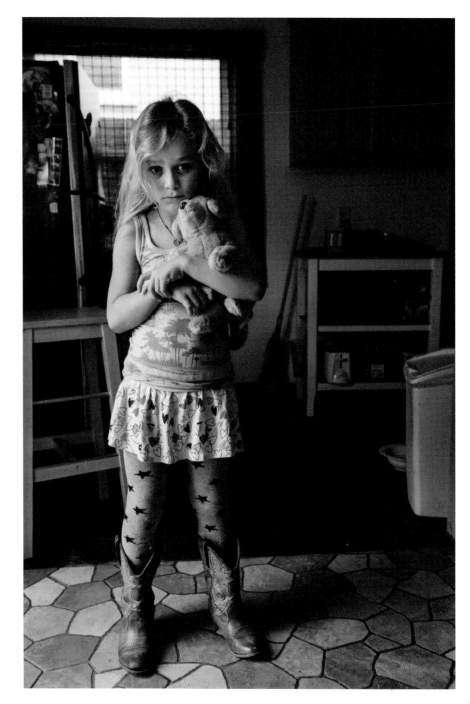

MARIA, student

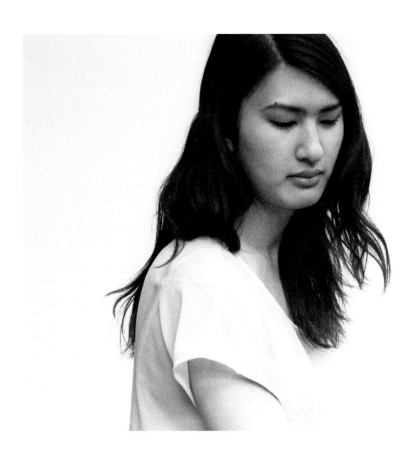

SUMMER, student

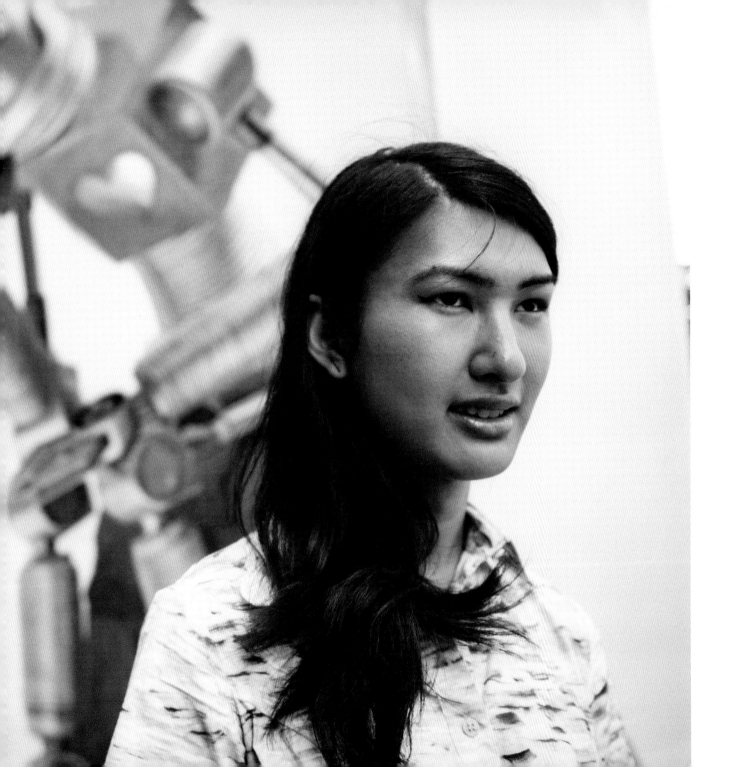

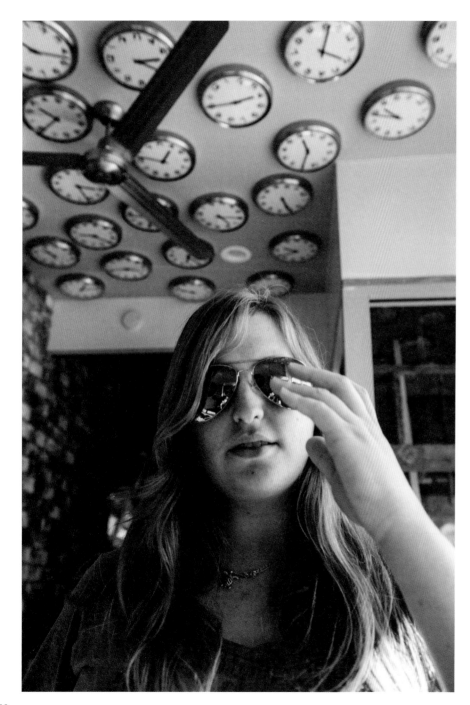

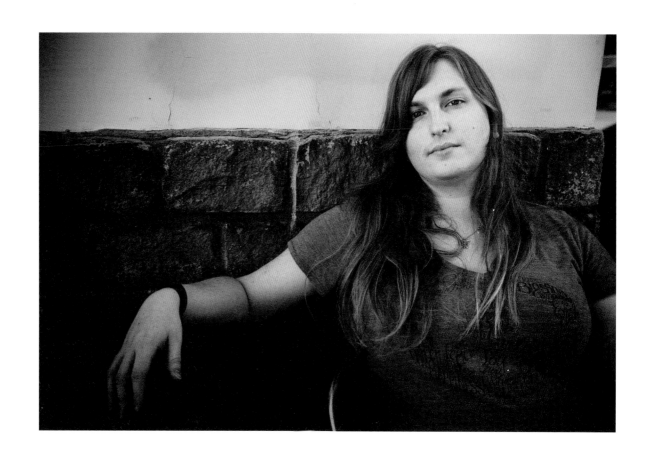

CLAIRE, electrologist

KAY, receptionist

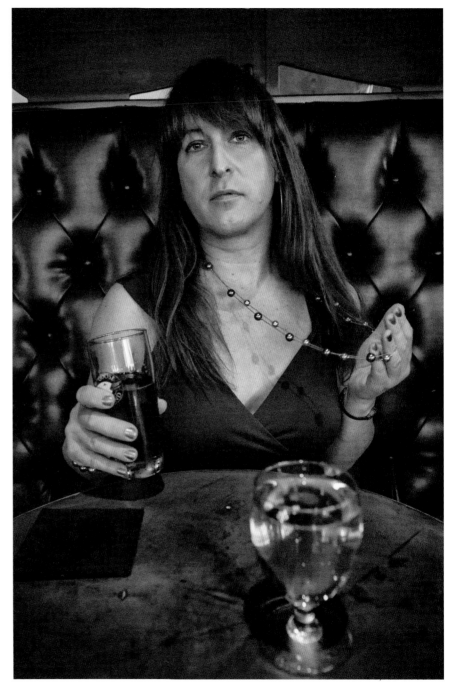

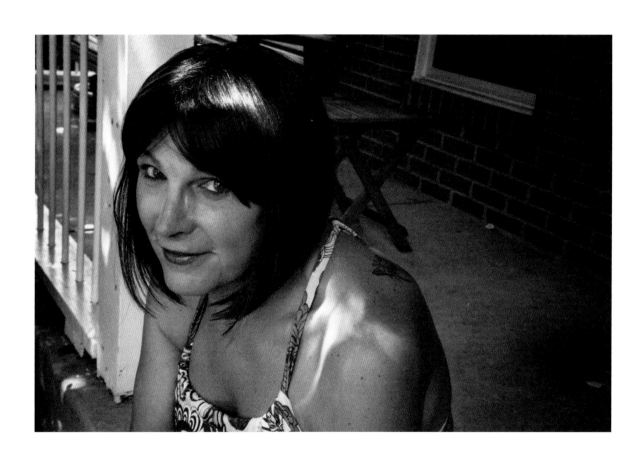

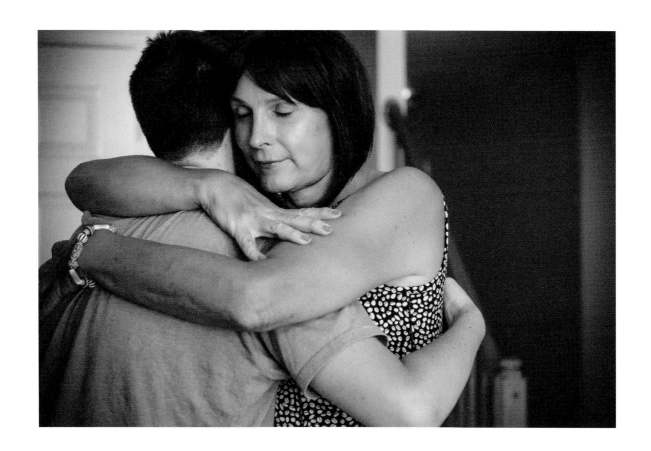

CONNIE, technical sales specialist
Interview: p.2

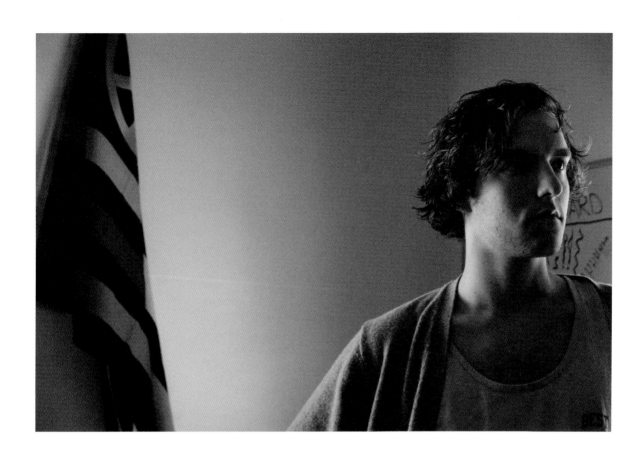

RYAN, student

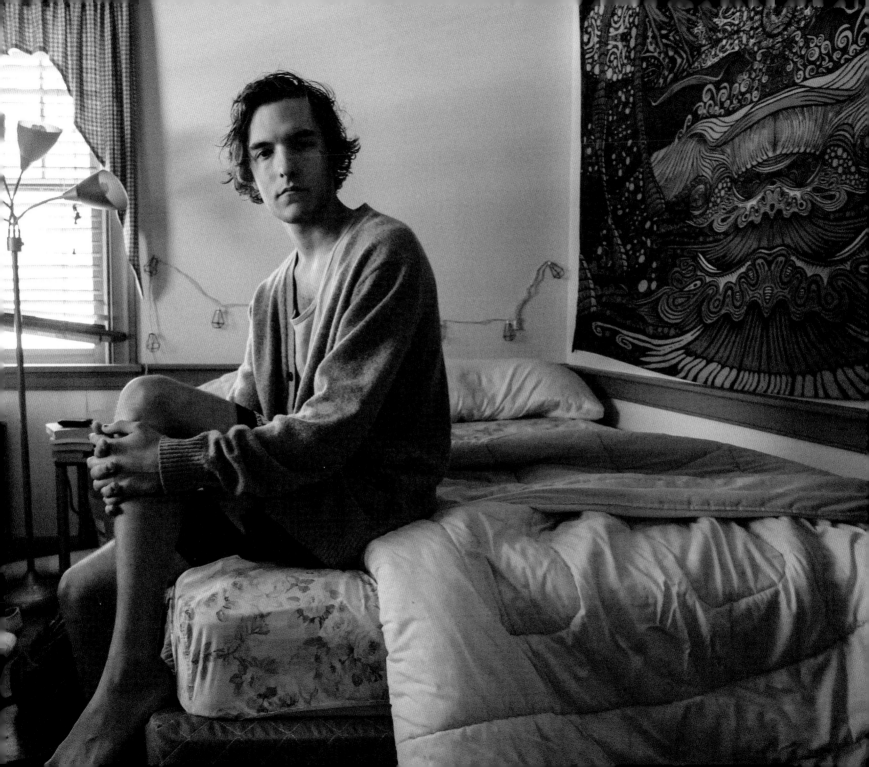

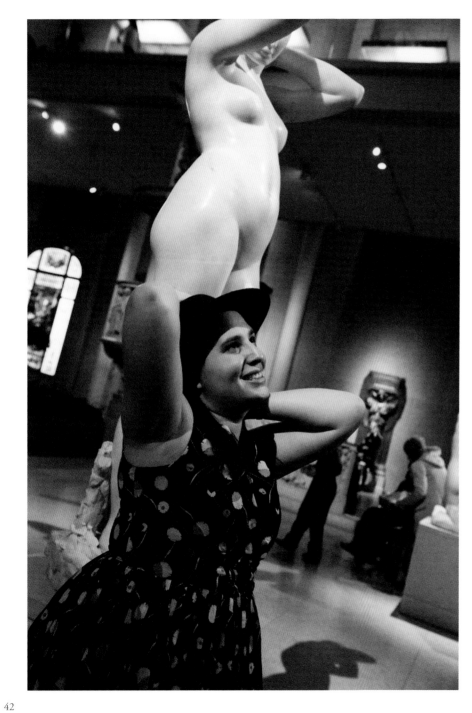

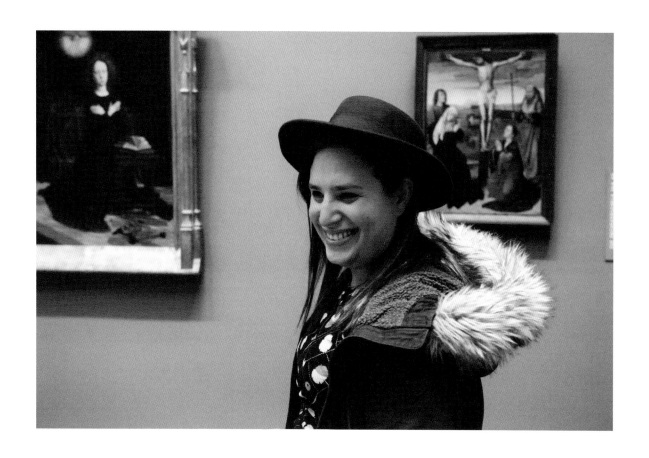

HANNAH, activist

DAWN, full-time mom

Interview: p.4

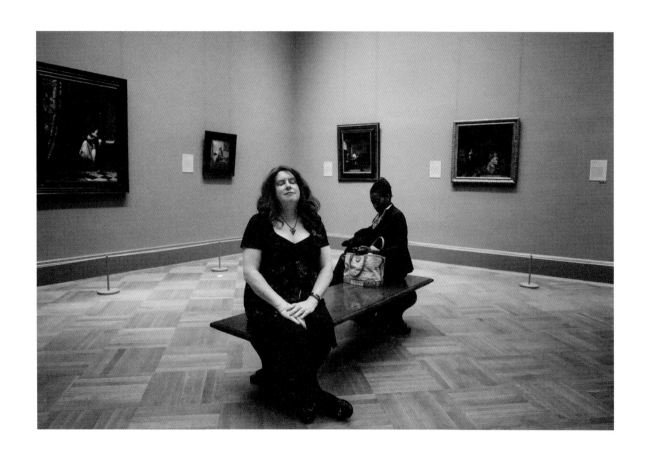

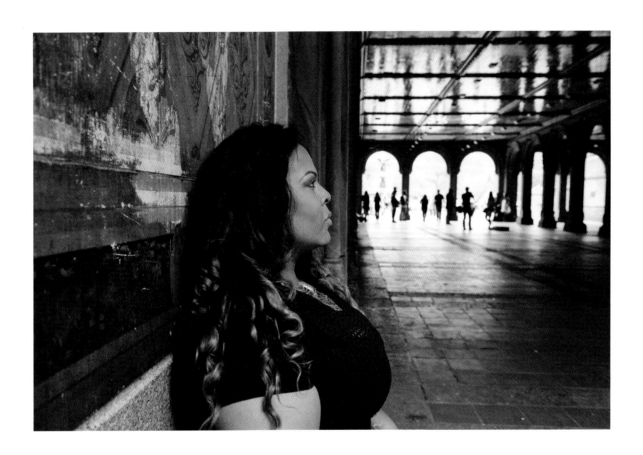

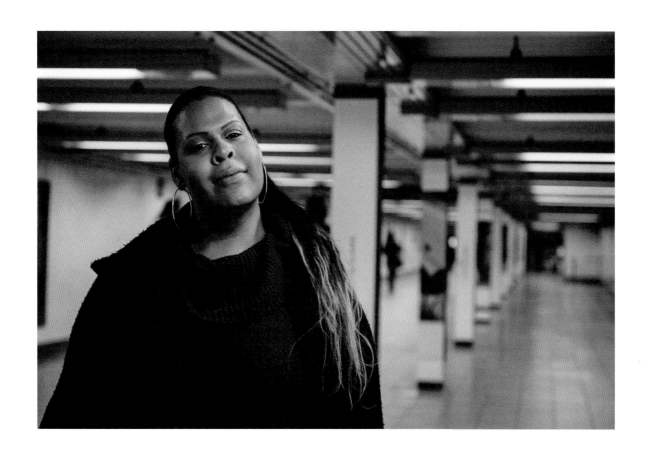

CHANEL, trans advocate

ALEXANDRA, IT engineer

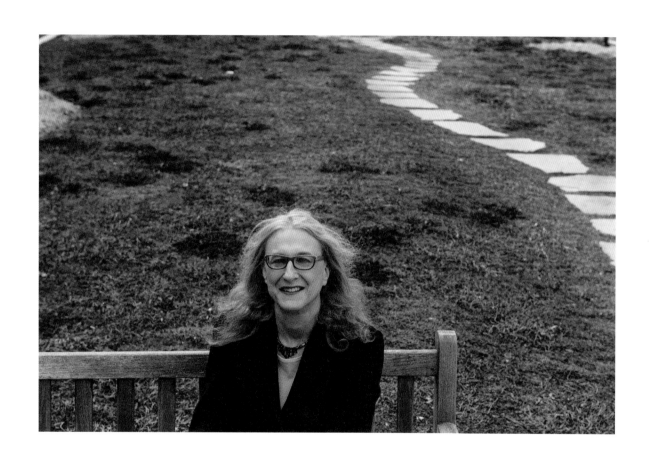

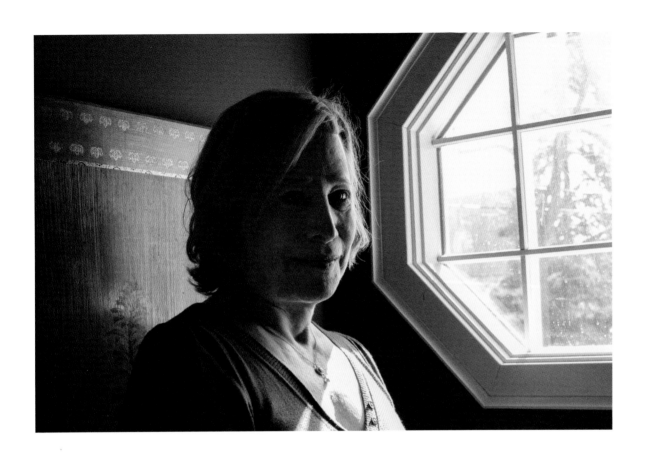

DANA, eye surgeon, activist

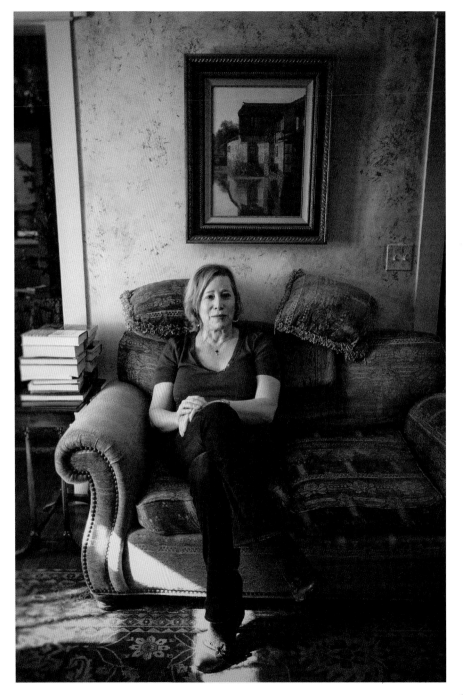

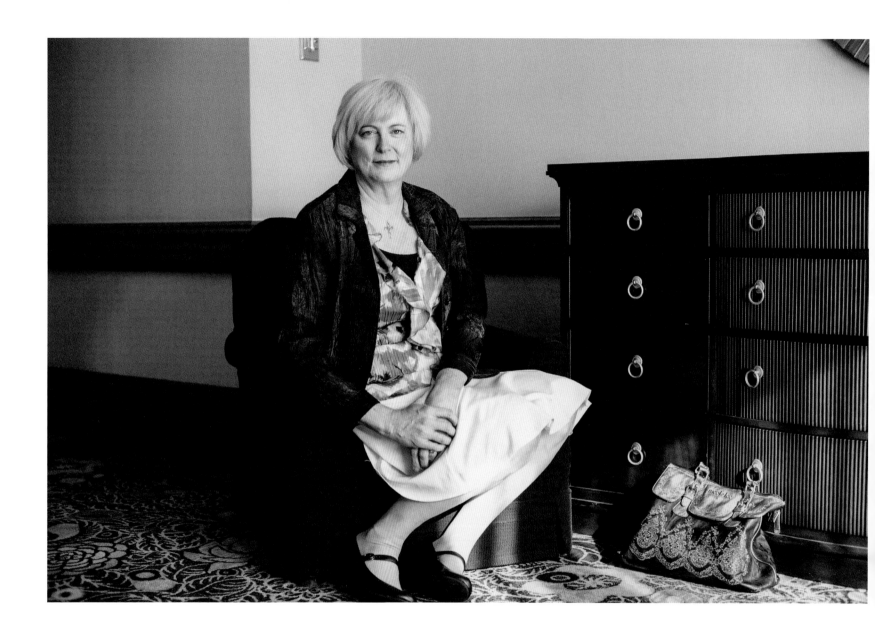

HILLARY, interior designer

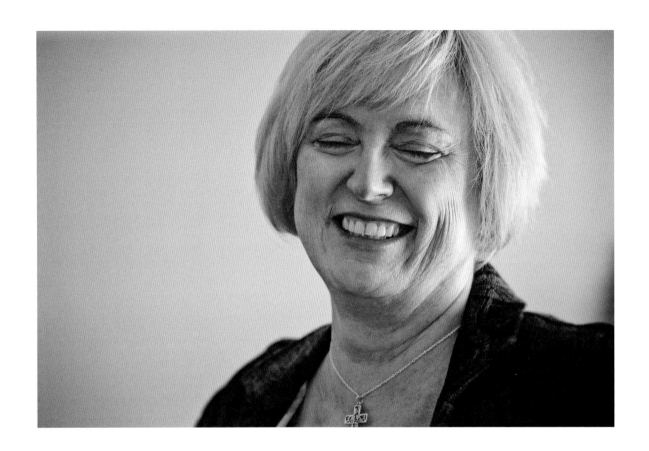

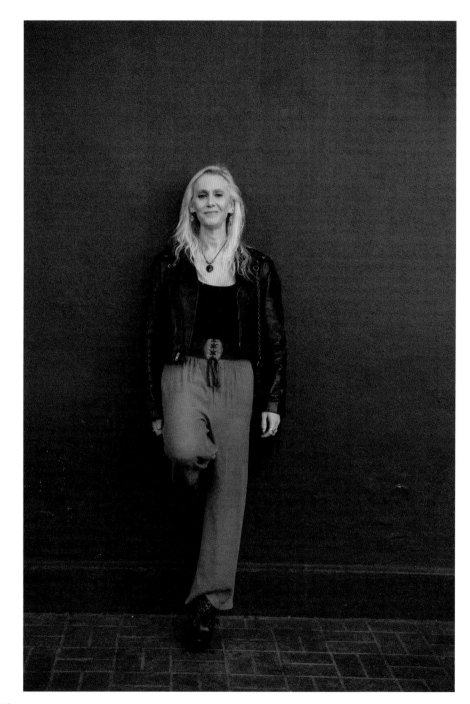

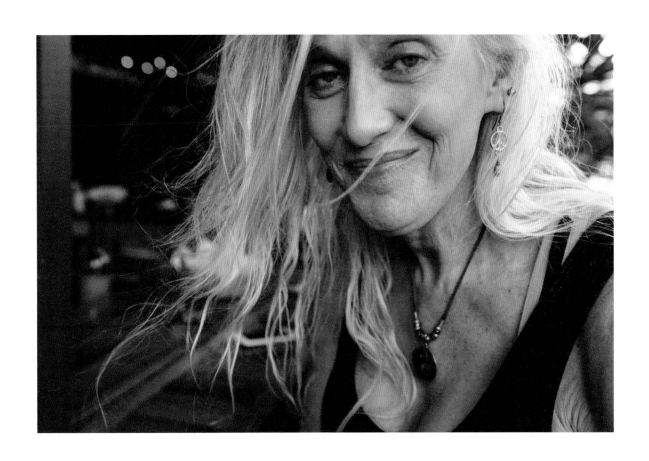

KATHIE, communications professor

CHRISSY, filmmaker

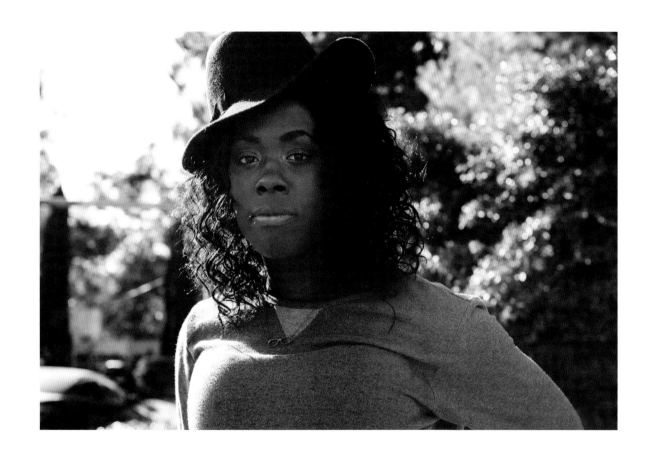

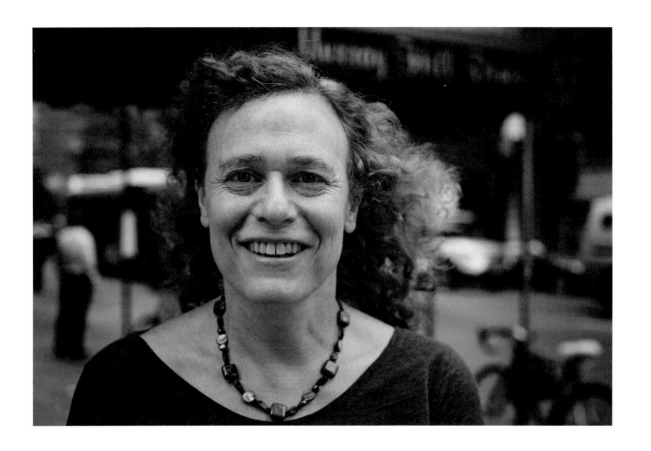

JOY, English professor

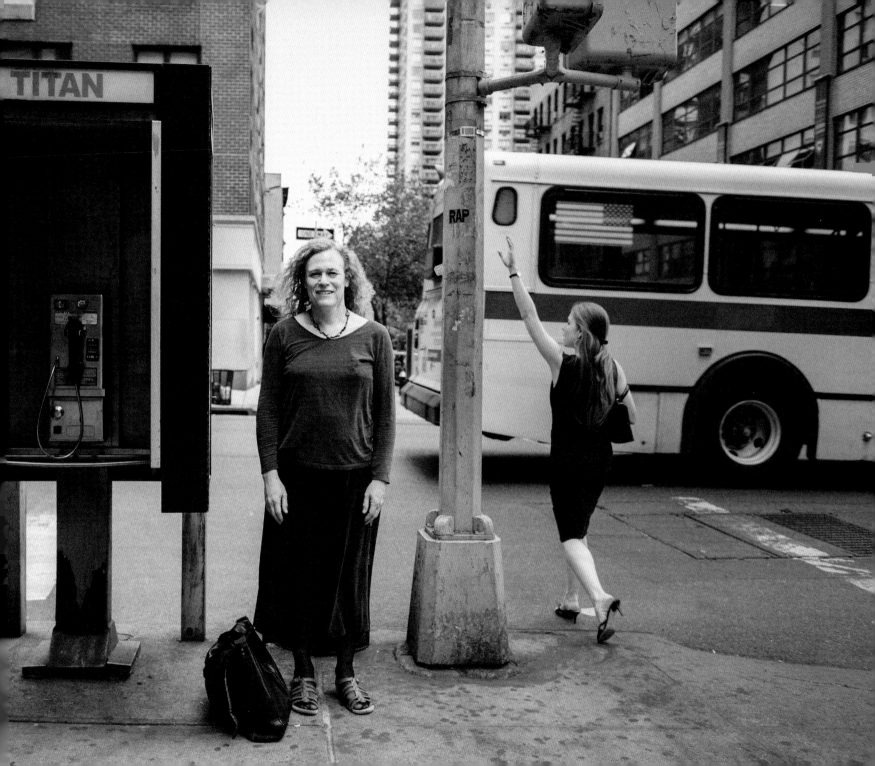

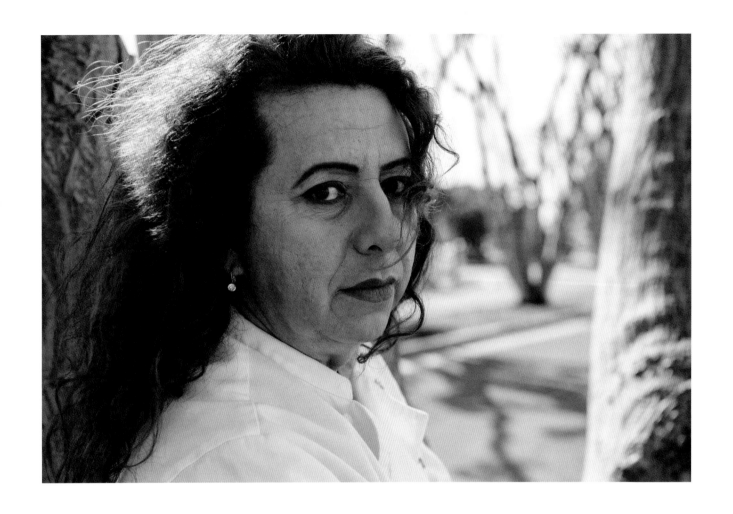

GISELLE, chef

Interview: p.14

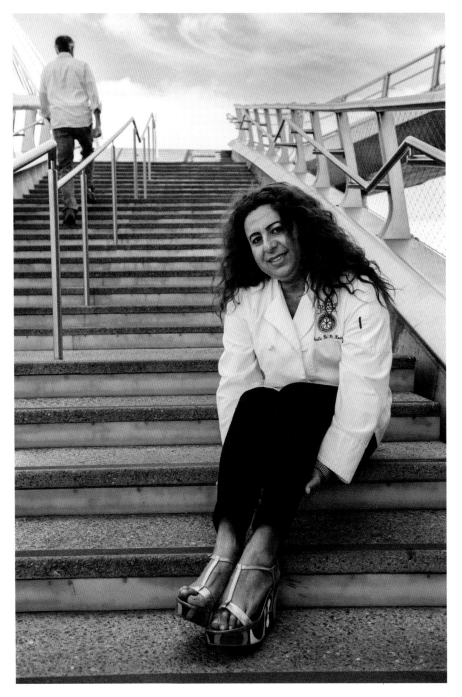

VANESSA, entertainer, activist

Interview: p.42

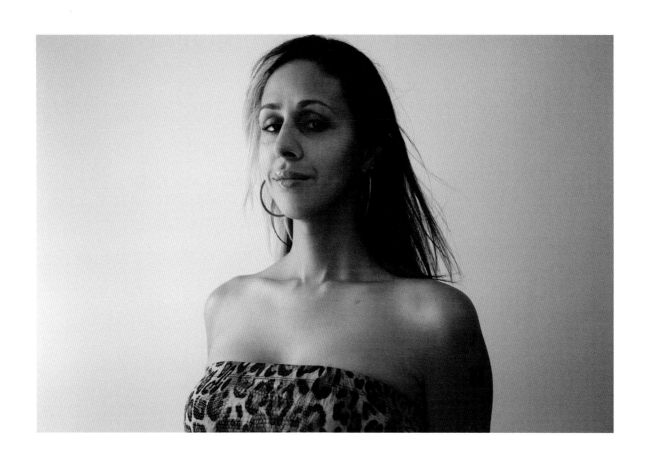

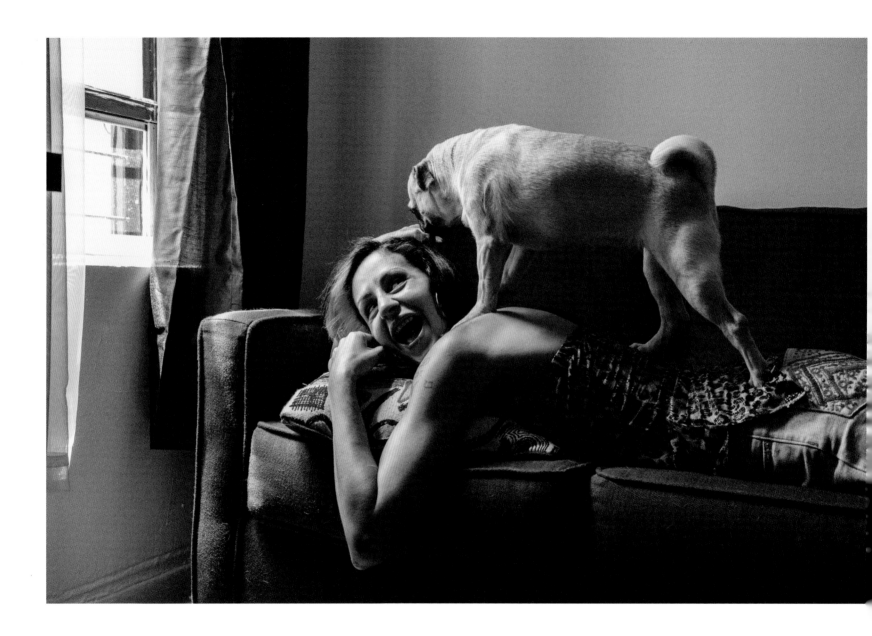

MEREDITH, documentary film producer

Interview: p.26

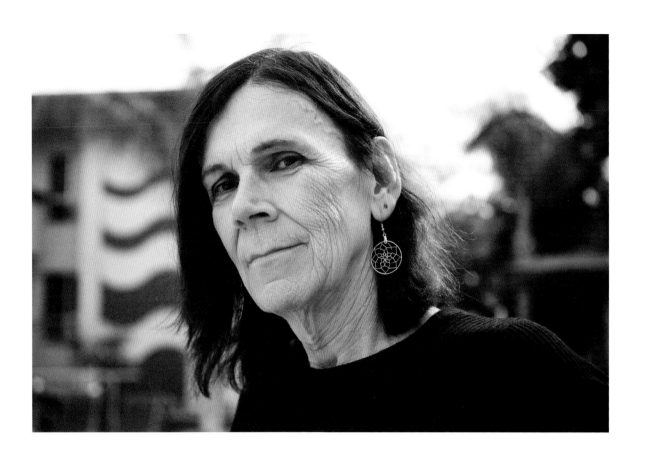

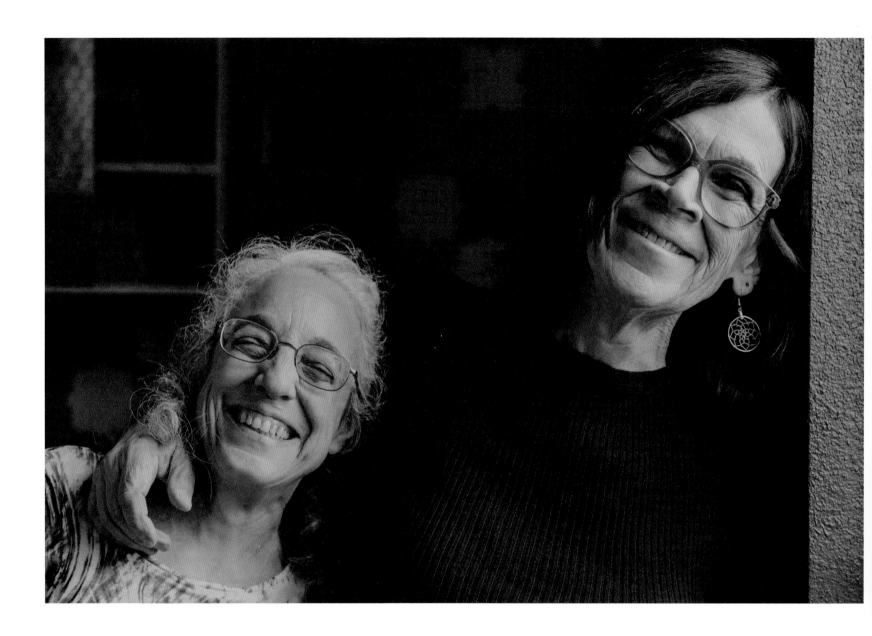

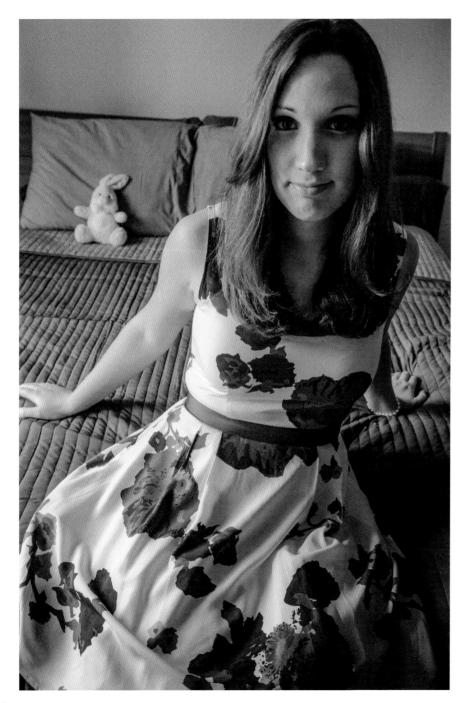

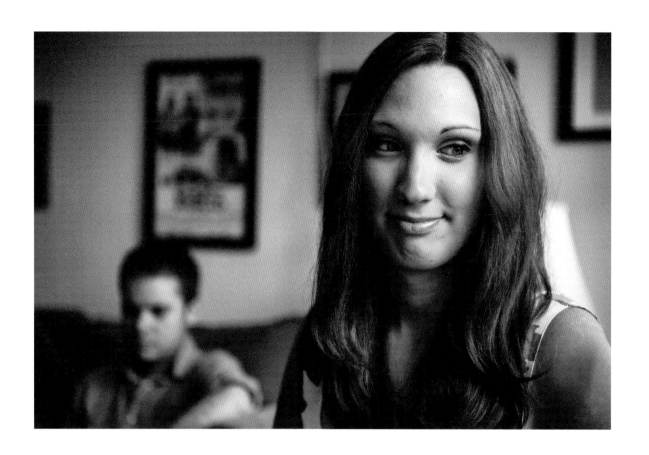

SARAH, press secretary

STEVIE, trade union organizer

Interview: p.40

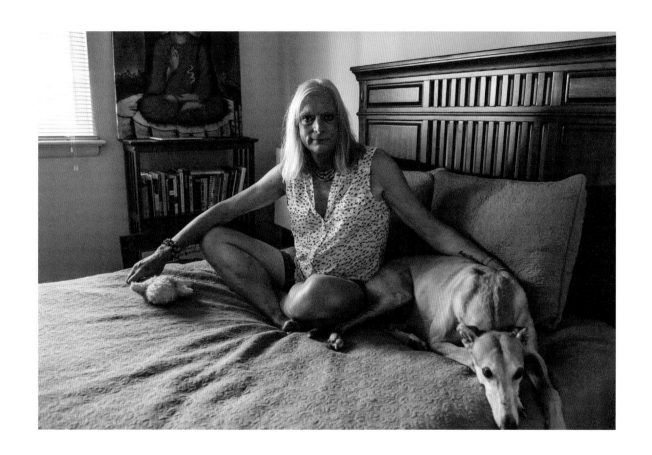

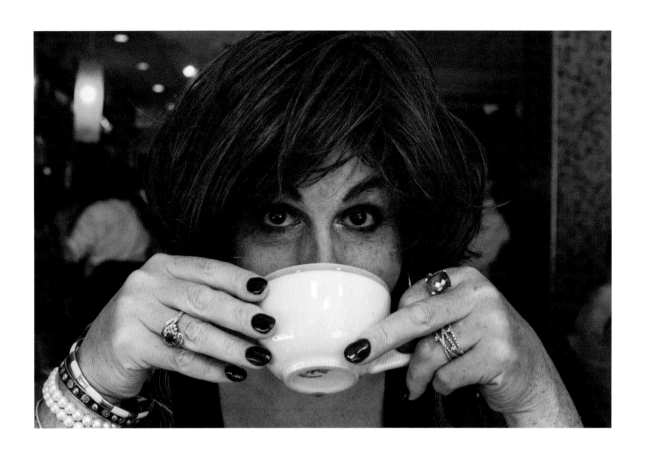

MELISSA, nonprofit fundraiser

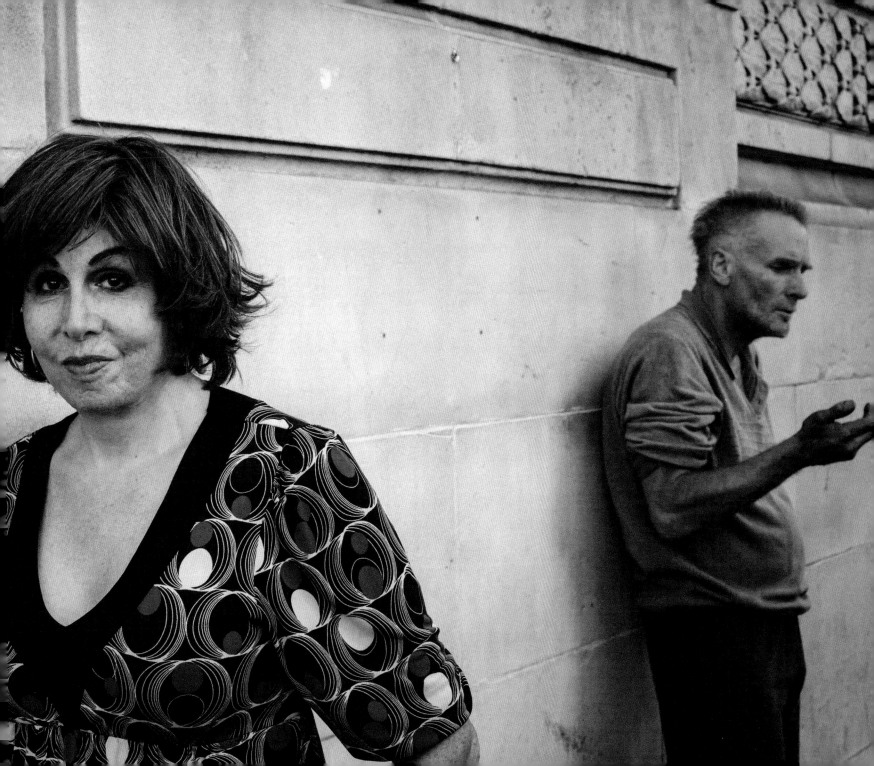

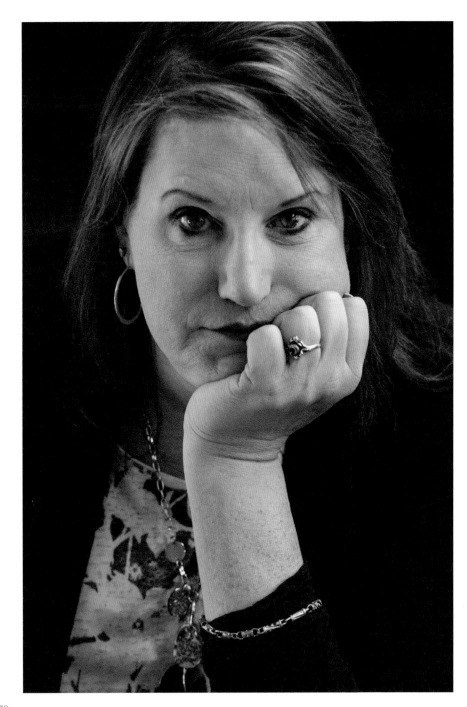

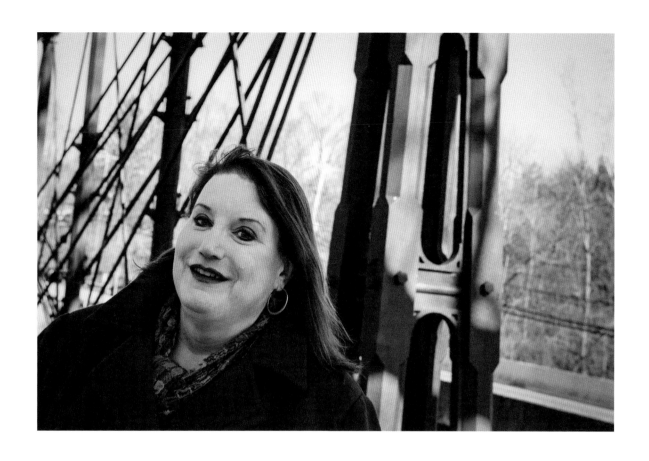

SHARON, computer engineer

Interview: p.32

PRIZILA, library technician

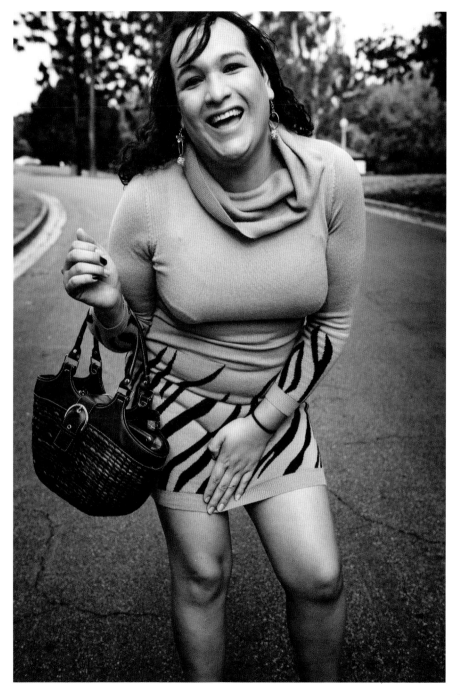

Acknowledgments

The most important person behind this book is my husband, Chris. If it weren't for him, this book would not have been possible. He helped me through the struggles and stood by me along the way.

I would also like to thank Michael Itkoff, for believing in this project from day one, and Ursula Damm, whose design vision for this book helped make it what it is.

Most of all, the women who appear in these pages were willing to trust an outsider whom they did not know. For that, I will always be grateful.